LE CINÉMA FRANÇAIS

An Illustrated Guide to the Best of French Films

written and illustrated by
Anne Keenan Higgins

RUNNING PRESS
PHILADELPHIA

Running Press
Hachette Book Group
1290 Avenue of the Americas, New York, NY 10104
www.runningpress.com
@Running_Press

Printed in China

First Edition: November 2018

Published by Running Press, an imprint of Perseus Books, LLC,
a subsidiary of Hachette Book Group, Inc. The Running Press name
and logo is a trademark of the Hachette Book Group.

The Hachette Speakers Bureau provides a wide range of authors
for speaking events. To find out more, go to
www.hachettespeakersbureau.com or call (866) 376-6591.

The publisher is not responsible for websites
(or their content) that are not owned by the publisher.

Print book cover and interior design by Amanda Richmond

Library of Congress Control Number: 2018941126

ISBNs: 978-0-7624-6346-6 (hardcover), 978-0-7624-6345-9 (ebook)

1010

10 9 8 7 6 5 4 3 2 1

TO TRISH, JOHN, BRIDGET, PETER,
CHRIS, JOE, ANDREW, AND EMILY

CONTENTS

Introduction

LES DIABOLIQUES ...**10**
(Diabolique)

ET DIEU . . . CRÉA LA FEMME ...**14**
(. . . And God Created Woman)

ASCENSEUR POUR L'ÉCHAFAUD ...**16**
(Elevator to the Gallows)

MON ONCLE ...**20**
(Mon Oncle)

LE BEAU SERGE ...**24**
(Le Beau Serge)

LES COUSINS ...**26**
(Les Cousins)

LES QUATRE CENTS COUPS ...**28**
(The 400 Blows)

HIROSHIMA MON AMOUR ...**32**
(Hiroshima Mon Amour)

À BOUT DE SOUFFLE ...34
(Breathless)

TIREZ SUR LE PIANISTE ...38
(Shoot the Piano Player)

ZAZIE DANS LE MÉTRO ...40
(Zazie dans le Métro)

L'ANNÉE DERNIÈRE À MARIENBAD ...44
(Last Year at Marienbad)

LOLA ...48
(Lola)

ADIEU PHILIPPINE ...50
(Adieu Philippine)

CLÉO DE 5 À 7 ...52
(Cleo from 5 to 7)

JULES ET JIM ...54
(Jules and Jim)

VIVRE SA VIE ...56
(My Life to Live)

LA BAIE DES ANGES ...58
(Bay of Angels)

LE MÉPRIS ...62
(Contempt)

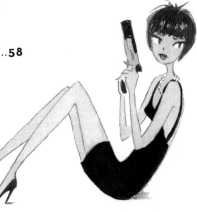

LA PEAU DOUCE ...64
(The Soft Skin)

LES PARAPLUIES DE CHERBOURG ...68
(The Umbrellas of Cherbourg)

UNE FEMME MARIÉE ...72
(Une Femme Mariée)

PIERROT LE FOU ...74
(Pierrot le Fou)

LE BONHEUR ...78
(Le Bonheur)

BELLE DE JOUR ...80
(Belle de Jour)

LES DEMOISELLES DE ROCHEFORT ...82
(The Young Girls of Rochefort)

LE SAMOURAÏ ...86
(Le Samouraï)

LA COLLECTIONNEUSE ...90
(The Collector)

LA FEMME INFIDÈLE ...92
(The Unfaithful Wife)

BAISERS VOLÉS ...94
(Stolen Kisses)

LE GRAND AMOUR ...98
(Le Grand Amour)

AU HASARD BALTHAZAR ...100
(Au Hasard Balthazar)

LES CHOSES DE LA VIE ...102
(The Things of Life)

LA NUIT AMÉRICAINE ...106
(Day for Night)

DIVA ...110
(Diva)

UNE CHAMBRE EN VILLE ...114
(Une Chambre en Ville)

DELICATESSEN ...116
(Delicatessen)

NIKITA ...120
(La Femme Nikita)

LE FABULEUX DESTIN D'AMÉLIE POULAIN ...124
(Amélie)

THE ARTIST ...128
(The Artist)

Acknowledgments ...130

Index ...131

INTRODUCTION

WHEN I FIRST SAW THE *NOUVELLE VAGUE* **(FRENCH NEW WAVE)** film *À bout de souffle* (*Breathless*), directed by Jean-Luc Godard, I wanted to be Jean Seberg. Her pixie haircut and androgynous style were, to me, the definition of cool. But, at the time, chopping off my very long hair was never going to happen. Instead, I found a pair of mod black sunglasses and stocked my closet with striped Breton shirts. The style of Ms. Seberg is but a small part of what you'll find when you delve into the forty French films this book celebrates.

Although *Le Cinéma Français* spans the 1950s to modern day, it emphasizes New Wave cinema, including award-winning films *Jules et Jim* (*Jules and Jim*), *Les quatre cents coups* (*The 400 Blows*), and *Les parapluies de Cherbourg* (*The Umbrellas of Cherbourg*). But latter-day cult films like *Diva*, *La Femme Nikita*, and *Amélie* are equally deserving of discussion. You may recognize most films by their French titles. I have included the official US release titles, too.

On these pages, you'll read about the work of François Truffaut, Claude Chabrol, Alain Resnais, and Agnès Varda—iconoclast directors who broke the rules of the traditional in-studio productions and shot on location, invented innovative camera techniques, and shared personal and political stories. The illustrations highlight the vibrant realism of the streets of Paris, quaint French villages, and beautiful beaches and villas along the coastline.

There is no need to be a film aficionado to enjoy this book; it is

for anyone enchanted by French culture. You will recognize movie icons, such as the timeless beauty Catherine Deneuve and femme fatale Brigitte Bardot, and meet a few less familiar actors, such as the incredibly handsome Alain Delon and hypnotizing Françoise Dorléac. Let these captivating creatures be your hosts on a one-of-a-kind tour of French cinema.

Vive la France!

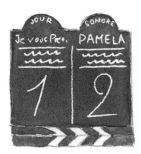

Les diaboliques
(DIABOLIQUE)

The movie opens in a small French town at the Delassalle Boarding School for boys, which is owned by a wealthy, fragile, and sickly headmistress named Christina (played by Véra Clouzot, the film director's wife). Michel Delassalle, her sadistic and abusive husband and the school principal, is openly having an affair with one of the teachers, Nicole, played by Simone Signoret. Nicole, too, is subject to his despicable treatment. The two desperate women soon bond over Michel's horrid behavior and join forces to devise a plan to do away with him for good.

Wasting no time, Nicole tampers with a bottle of whiskey and persuades Christina to make Michel drink it. The co-conspirators then drag his drugged body into a tub full of water, drown him, and dump his waterlogged body into the school's filthy swimming pool. The true intrigue of the movie begins when Michel's body mysteriously disappears from the pool and the suit he was wearing returns from the dry cleaner. After that, Christina begins to see and hear things that aren't really there—or are they?

Days later, a body turns up in the Seine, and Christina is asked to meet Inspector Fichet at the morgue. Unfortunately, it's not Michel, and Fichet offers some unwanted help to find her husband. As he digs deep into the case, Christina and Nicole remain bundles of nerves and anxiously wait an ending, which no one sees coming.

Les diaboliques has been described as one of the most suspenseful psychological thrillers of all time. With its masterful surprise ending, Clouzot was compelled to implore viewers not to reveal the ending to their friends, and he added a final frame with the message: "Do not be devils! Do not ruin the interest your friends could take in this film. Do not tell them what you saw. They'll thank you."

Directed by Henri-Georges Clouzot, 1955
Starring Simone Signoret, Véra Clouzot, and Paul Meurisse

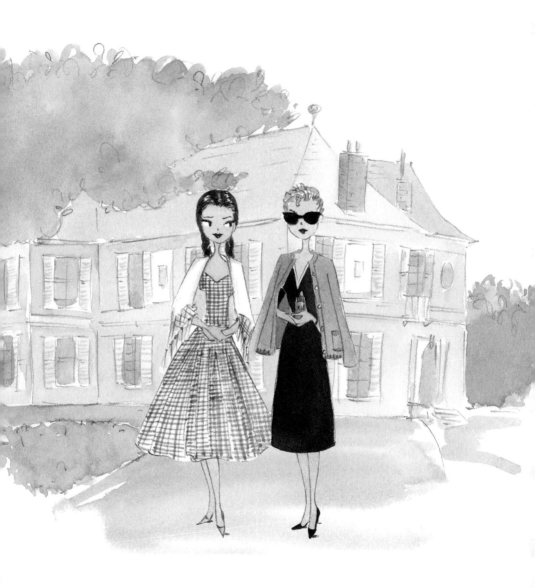

Michel's bamboo
cigarette holder

Michel's suit
from the
dry cleaners

Class picture with what looks like Michel
peeking through the window

Wicker trunk where Christina
and Nicole transported Michel's body

Whiskey and sedative
used to drug Michel

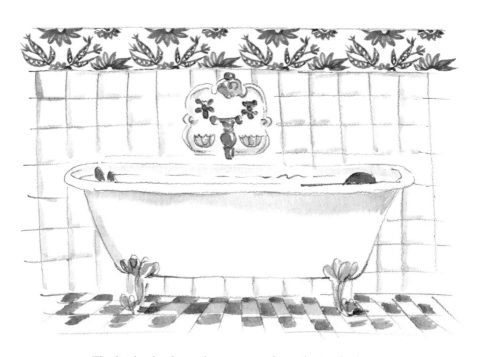

The bathtub where the supposed murder took place

Et Dieu ...créa la femme
(... AND GOD CREATED WOMAN)

The film is set against the backdrop of Saint-Tropez and stars Brigitte Bardot as the orphaned sex kitten Juliette, so, as you can imagine, the visuals are spectacular. Known as the town trollop, Juliette drives men crazy in her curvaceous wiggle dresses, sultry glances, and dynamic rendition of the Mambo. She effortlessly captivates three men: the wealthy, middle-aged Eric Carradine; handsome Antoine Tardieu; and Antoine's shy younger brother, Michel.

After Juliette realizes she's not good enough for Antoine, she reluctantly marries Michel. When Antoine leaves town, Juliette attempts to be the good wife, but once he returns home, she seduces the man she thinks she loves. Michel, infuriated by the betrayal, searches for Juliette and finds her in a drunken dance frenzy at the local barroom, Bar des Amis. When Juliette ignores Michel and continues her memorable scene-stealing dance moves, he pulls out a gun. Monsieur Carradine, who moments earlier tried to steal Juliette away, realizes she will never love him and courageously takes a bullet for her. Husband and wife soon reconcile, but Carradine declares, "That girl is made to destroy men," and it's obvious trouble will come knocking again.

Bardot was married to the director, Roger Vadim, at the time of filming, and *Et Dieu ... créa la femme* catapulted them both into the limelight despite opening to less-than-stellar reviews in France. French critics stated that the "vulgarity" on display was a terrible representation of the nation. Nevertheless, the film became a huge success worldwide and sent Bardot on her way to icon status.

Directed by Roger Vadim, 1956
Starring Brigitte Bardot, Curd Jürgens, and Jean-Louis Trintignant

Ascenseur pour l'échafaud
(ELEVATOR TO THE GALLOWS)

"*Je t'aime, je t'aime*," says Florence (played by the sensuous Jeanne Moreau), professing the depth of her passion for her lover, Julien, as he is about to murder Simon Carlala, her wealthy husband and Julien's employer. After Julien finishes off Carlala, he rushes outside to his car but sees the rope he used to climb up to his boss's office dangling. Leaving his car running, he rushes back into the office building only to be trapped in the elevator after the power is turned off for the evening. Julien is unable to meet Florence, who is waiting for him at a café.

Louis Malle, in his first directorial effort and just twenty-four years old, keeps the action tense as the story unfolds. He hired jazz musician Miles Davis to compose the groundbreaking score that showcases Florence's anguish as she wanders the rainy streets of Paris desperately in search of Julien.

Finally, the building's power is restored; Julien is set free, but his car has been stolen by Louis and Veronique, an impulsive young couple with a predilection for big American cars. The two meet a chatty older German couple, the Benkers, who own an irresistible Mercedes-Benz 300SL. Louis attempts to steal the car but gets caught, then shoots and kills Monsieur Benker. Julien's stolen car is found at the crime scene and he is accused of a murder he didn't commit. The plan that was supposed to bring him and Florence together quickly turns complicated and may push them apart forever.

Directed by Louis Malle, 1958
Starring Jeanne Moreau, Maurice Ronet, and Georges Poujouly

Grappling hook and rope used to
climb into the boss's window

Minox Spy Camera

Mercedes-Benz 300SL

Elevator switch panel

Tools used to escape
the elevator shaft

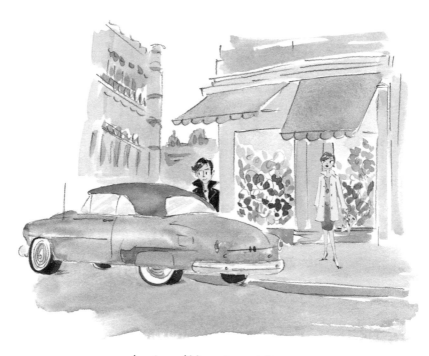

Louis and Veronique right
before they steal Pierre's car

Mon oncle
(MON ONCLE)

Mon oncle almost plays as a crystal ball foreshadowing today's obsession with technical gadgetry. It's set in two different worlds: the charming "old quarter" of Paris and a sterile up-and-coming neighborhood, where the houses are boxy and full of devices, from automatic gates to a fish-shaped fountain that spouts water at the push of a button.

A jaunty musical score and one cleverly constructed gag after another enhance the film. The colorful cast includes schoolboy pranksters, a street sweeper who never sweeps because he's always caught up in conversation, and a group of dogs that happily run in and out of scenes through the entire movie. The main character is the endearing pipe-smoking Monsieur Hulot, played by Jacques Tati, who also served as the director.

Young Gerard is Hulot's nephew, who would rather spend time with his entertaining, absentminded uncle than his gizmo-obsessed parents. Gerard's affection for Uncle Hulot doesn't sit well with his father, M. Arpel, so to give them less time to pal around, Arpel finds employment for his brother-in-law at his plastics factory. Not cut out for a confined desk job, Hulot inevitably dozes off while a machine he is overseeing starts to malfunction. Upon noticing the glitch, he hilariously makes a bad situation even worse. The machine that's supposed to make plastic tubing starts spitting out tubes that resemble sausage links.

The constant back-and-forth from old world to new is creatively woven into this entertaining feature. The film emphasizes that the world will always move forward, but one should make time to slow down, take a break from the latest gadget, and enjoy the fleeting moments as they happen.

Directed by Jacques Tati, 1958
Starring Jacques Tati, Jean-Pierre Zola, Adrienne Servantie, and Alain Bécourt

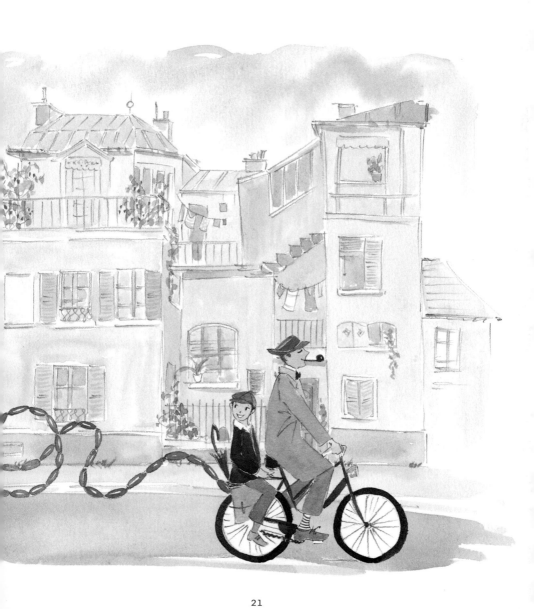

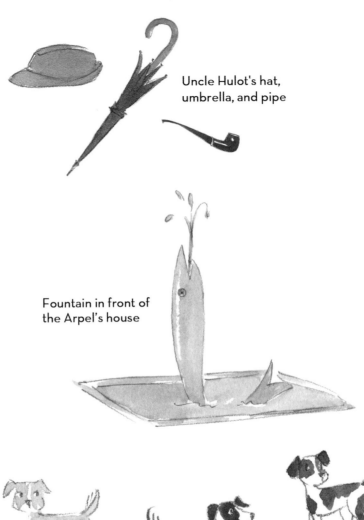

Uncle Hulot's hat,
umbrella, and pipe

Fountain in front of
the Arpel's house

Dogs that run around
with the Arpel's dog

Ultra-modern home of the Arpels

Arpel's dog catching up to his friends

Le beau Serge
(LE BEAU SERGE)

François Baillou, a savvy Parisian who contracts tuberculosis, returns to his small hometown of Sardent for rest. The minute he steps off the bus, he runs into one of his closest childhood friends, Serge, and discovers the once golden boy has become a bitter alcoholic, unhappily married to his wife, Yvonne. The married couple is expecting a child. After losing a first baby to complications of Down syndrome, they are convinced they will have another special-needs child. It also doesn't help that Marie, Yvonne's younger sister and the town trollop, had an affair with Serge and now has her eye on François.

François becomes obsessed with Serge and the desire to fix the problems that led to his idol's self-destruction and misery. But Serge doesn't welcome François's assistance and becomes resentful when he fails to convince his old friend that their dire circumstances are a normal part of life. François can't help himself, and when Yvonne goes into labor during a snowstorm, he is determined to locate the doctor and Serge, who is sleeping off a bender in a henhouse. Running around in the cold winter air takes its toll on François's fragile health, but he finds the strength to bring Serge back just in time to hear the sound of his baby boy being born. This new life may heal a friendship and possibly provide the break Serge has been looking for.

Le beau Serge, Claude Chabrol's first film, is often credited with igniting the *Nouvelle vague* movement. Using natural lighting, shooting entirely on location (in his hometown of Sardent), and depicting the austere personal chaos of the story are a few signature qualities that Chabrol used to reinvent French cinema.

Directed by Claude Chabrol, 1958
Starring Jean-Claude Brialy, Gérard Blain, Michèle Méritz,
and Bernadette Lafont

Les cousins
(LES COUSINS)

Naive mama's boy Charles moves to Paris to live with his womanizing and decadent cousin Paul while they both attend law school. The two cousins could not be more different. Self-possessed Paul, who claims he never needs to study, hosts raucous parties while Charles stays in his room frantically hitting the books. When Paul convinces Charles to go out to a club, the latter meets and instantly falls in love with Florence, an attractive woman with a questionable reputation. It soon becomes clear she's interested in restoring her character by having a relationship with an innocent and unsuspecting man like Charles.

When the couple makes a plan to meet, Florence mistakenly shows up at the apartment two hours early and is invited in by Paul to stay and wait for Charles. Soon, Paul and his devious friend Clovis convince Florence that she would eventually tire of Charles and that she is better matched with Paul. Florence and Paul end up going to bed together. When Charles returns, Paul announces his feelings for Florence and that she's moving in with them. Charles acquiesces and returns to his studies.

Finally, exam day arrives. Losing Florence proved too distracting to Charles, and the results of his tests are disappointing. Unable to sleep, a distraught Charles is torn between killing himself and killing his cousin, but they both make it through the night alive. However, the next morning, a playful mishap changes the cousins' lives forever.

Director Claude Chabrol made Les cousins when he was just twenty-seven years old. The film has an essential place in the French New Wave oeuvre, with its use of young new actors, stylish sets, modern costumes, and socially rebellious characters.

Directed by Claude Chabrol, 1959
Starring Gérard Blain, Jean-Claude Brialy, and Juliette Mayniel

Les quatre cents coups
(THE 400 BLOWS)

As François Truffaut's directorial debut, *Les quatre cents coups* is also required French New Wave viewing. The literal translation of the title comes from the idiom *"faire les quatre cents coups,"* which means to "raise hell." Winner of the Best Director Award at Cannes, this semi-autobiographical story is about a misunderstood adolescent, Antoine Doinel, who is neglected by his parents and treated as a lost cause by his teachers.

Antoine, living in a cramped Parisian apartment with his selfish mother and indifferent stepfather, is a typical rambunctious teen who invariably gets caught in one mischievous situation after another. He finds solace in skipping school with his friend Rene to escape to the cinema for a few hours. But after cutting class, concealing a failing grade after being (falsely) accused of plagiarism, and being apprehended as he returned a typewriter he stole from his stepfather's office, Antoine is ordered to go to a school for delinquents at the suggestion of his mother. First, he spends a night in the police station with crooks and prostitutes and then, in the back of a paddy wagon with tears streaming down his face, leaves one grievous life and enters another.

Part of what makes *Les quatre cents coups* so appealing is the entertaining moments of nuance that the camera catches, such as the fascination of small children watching a puppet show and the goofiness of a classmate who cannot write a single word without spilling ink on the pages of his workbook. The film is considered one of the best French films of all time. Its originality continues right up to the unsettling famous freeze-frame ending, which remains fresh almost sixty years later.

Directed by François Truffaut, 1959
Starring Jean-Pierre Léaud, Albert Rémy, and Claire Maurier

Hat worn to conceal his identity
when returning the typewriter

Typewriter Antoine steals and
tries to sell for cash

A shrine to French
novelist and playwright Balzac

Antoine's battered school bag

A few items Antoine steals
throughout the film

Antoine locked in jail cell
before he's taken to reform school

Hiroshima mon amour
(HIROSHIMA MON AMOUR)

Each frame of *Hiroshima mon amour* is a beautifully stylized cine-matic composition. Revolving around memories of World War II, this complex film takes the viewer through the effects of war and how locking away painful recollections can shape people's behavior. For director Alain Resnais, the film became an international success and an early influencer of French New Wave cinema.

Fourteen years after the war, actress Elle, who lives in Paris, is in Hiroshima to shoot an antiwar film titled *For Peace*. She meets Lui, a Japanese architect, in a hotel bar. They immediately connect and begin a brief but passionate affair. The setting leads to a deep dis-cussion of the memories left behind after the bombing of Hiroshima. Elle's observations are based on the documented images she has seen, but Lui, who lost his family to the destruction, insists she can never really know what it was like because she didn't experience it.

When they meet again, Elle shares her own harrowing experience of the war in German-occupied Nevers, France. She reveals she fell in love with a German soldier, and through flashbacks the film cuts to Nevers, where Elle secretly meets with the soldier. On the last day of the war, Elle waves to the soldier from the top of a bridge and is devastated to see her first love shot and killed. When her forbidden love is found out, Elle becomes a disgrace to her parents and towns-people. With Lui as an intent listener, she pushes her sad story about shame and lost love to the surface, helping to release the immense burden she has been carrying around and trying to forget for most of her life.

Directed by Alain Resnais, 1959
Starring Emmanuelle Riva and Eiji Okada

À bout de souffle

(BREATHLESS)

À bout de souffle is directed by the audacious Jean-Luc Godard, who once said, "To make a film all you need is a girl and a gun." Here, the girl is an American student, Patricia, played by gamine Jean Seberg, who peddles the *New York Herald-Tribune* up and down the Champs-Élysées. The gun belongs to her quasi-boyfriend and Humphrey Bogart wannabe, Michel.

Throughout the film, the couple seems to be in love, but their youth and narcissism cloud any true deep devotion. Bad-boy Michel breaks the law twice in the first five minutes of the film—first by stealing a car and then by shooting a police officer. Patricia, who may or may not be pregnant with Michel's baby, doesn't bat a lovely eye when she finds out he is a thief, a killer, and married.

Detectives question Patricia, and she attempts to wiggle out of knowing Michel, but they are on to her. The police follow the couple through the streets of Paris until Patricia and Michel finally shake them by hiding in a friend's photo studio. An uneasy Patricia begins to question whether she should betray Michel and turn him in to the authorities. She claims she isn't sure she loves him, but it's clear she doesn't want to be dragged down with him.

Directed by Jean-Luc Godard, 1960
Starring Jean Seberg and Jean-Paul Belmondo

Patricia's
teddy bear

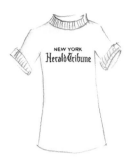

Patricia's iconic
New York Herald Tribune
T-shirt

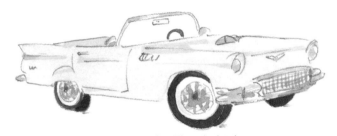

Michel's stolen Thunderbird

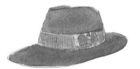

Michel's fedora

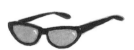

Patricia's mod
sunglasses

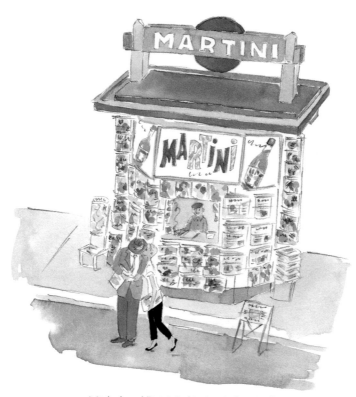

Michel and Patricia kissing in front of
a newstand along the Champs-Élysées

Tirez sur le pianiste
(SHOOT THE PIANO PLAYER)

Tirez sur le pianiste follows Edouard, a former concert pianist who works in a dive bar under the assumed name of Charlie. He's living a quiet life and raising his younger brother Fido. One night, Charlie's brother Chico, whom he has not spoken to in four years, suddenly rushes into the bar and asks Charlie for help. Chico explains that he and their other brother Richard are on the lam from two bumbling thugs they double-crossed during a robbery. Charlie doesn't want to have anything to do with them, but before he knows it, he's in deep.

Meanwhile, sparks fly between Charlie and Léna, a server at the bar. The two end up kidnapped by the thugs, but what should be a harrowing car ride turns into comical banter among the four of them. The couple manages to get free, but when Léna reveals that she knows Charlie is really Edouard, his tragic memories flood back and the movie suddenly shifts from humor to drama. After Charlie shares his heartbreaking story with Léna, she decides they should begin a new life, with him returning to playing prestigious concert halls.

Not so fast! When Charlie and Léna quit their jobs at the bar, a deadly scuffle breaks out with the owner and they escape to his brother's cabin in the woods. The scenery changes from dirty city streets to serene snowy hillsides, but the peaceful surroundings turn violent. Just when it seems like Charlie has regained his spirit, the woman he loves is taken away and he's back to playing the piano for an audience that barely notices him.

Tirez sur le pianiste is based on an American crime novel that director Truffaut turned into a dark comedic gangster film. Ironically, it was a genre he disliked, but as a director he decided to make the movie and pay homage to the American films that greatly influenced his career.

Directed by François Truffaut, 1960
Starring Charles Aznavour, Marie Dubois, and Albert Rémy

Zazie dans le Métro
(ZAZIE DANS LE MÉTRO)

Zazie, a precocious, potty-mouthed little girl, travels to Paris to stay with her uncle Gabriel (a cross-dressing Spanish ballerina) so her mother can have an uninterrupted romantic rendezvous with her new boyfriend. All Zazie wants to do is ride the Métro. But after finding out it's shut down because of a strike, she hits the ground running and takes her uncle and an eccentric cast of characters on an adventure through Paris they'll never forget.

The film is adapted from the popular French novel of the same name by Raymond Queneau. Director Louis Malle stays true to the book but changes Zazie's age from sixteen to ten years old and uses almost every cinematic trick imaginable, from fast motion and jump cuts to endless chase scenes and animated explosions. While *Zazie dans le Métro* is a zany slapstick comedy, it also has dark and even sexual overtones. In one scene, Zazie devours a plate of mussels (she finds a pearl in one of them and tosses it over her shoulder) while describing an uncomfortable personal story of pedophilia, and later she incessantly inquires about her uncle's homosexuality while climbing down the Eiffel Tower from a harrowing height. These topics, among others, are blended at high speed into nutty scenes with a style reminiscent of the Three Stooges and Keystone Cops at their finest.

Zazie's smart-aleck comebacks and knack for outsmarting almost every adult she meets finally get her a ride on the Métro, but after an exhausting weekend it would be a miracle if she can stay awake long enough to enjoy the trip.

Directed by Louis Malle, 1960
Starring Catherine Demongeot, Philippe Noiret,
Vittorio Caprioli, and Carla Marlier

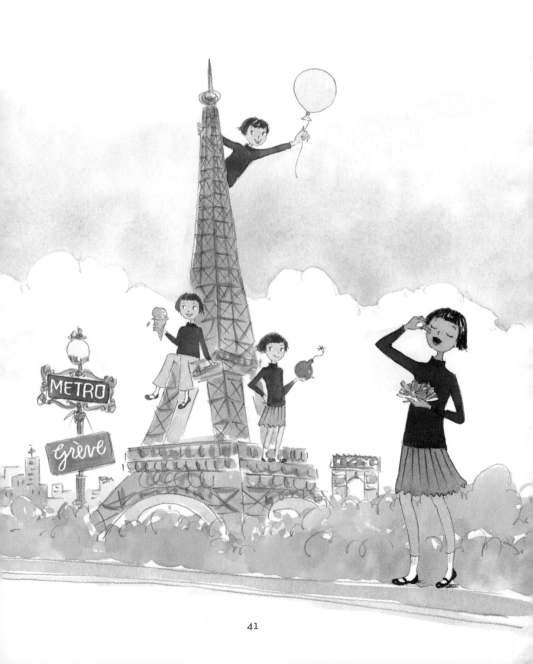

METRO

grève

Albertine,
Uncle Gabriel's wife

Zazie's suitcase

Dynamite is one of
Zazie's endless props

Zazie's Uncle Gabriel

A pearl Zazie
finds in a mussel

Lonely Madame Mouaque
who looks to
Zazie for friendship

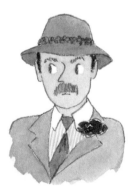

Balloon used to
float down from
the Eiffel Tower

Creepy Trouscaillon
chases Zazie through Paris

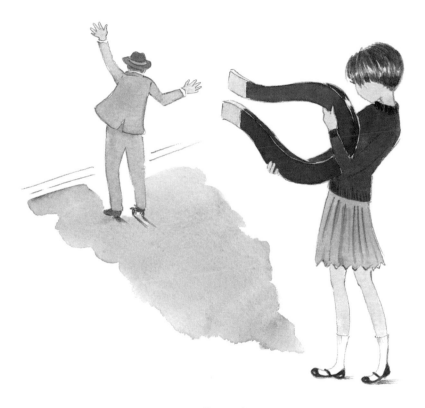

Zazie pulls another
prank with a giant magnet

L'année dernière à Marienbad
(LAST YEAR AT MARIENBAD)

If you're like most audiences, the unforgettable, highly stylized, and moody film *Last Year at Marienbad* will ignite frustration, visual delight, or plain confusion. The central characters are never referred to by their names; however, in the published script, the female lead—played by the exquisite Delphine Seyrig—is labeled "A," the male lead (Giorgio Albertazzi) is "X," and "A's" husband is "M" (Sacha Pitoëff).

"X," who serves as narrator, claims he met "A" the year before, at Marienbad, but she repeatedly tells him they have not met. Scenes are shot as if they're dreams, or maybe vague flashbacks (the viewer is never quite sure). For example, "A" is shown outside, outfitted in an exotic sequined-and-feathered cape, and seconds later she is standing in a hotel bar wearing a chiffon dress, shrieking, surrounded by startled guests. "M" slithers in and out of the story and challenges guests to play an illogical matchstick game that only he can win. It's a game that seems to give him a semblance of control that he's clearly lacking in his marriage.

Last Year at Marienbad is a film that's not to be missed—for Sacha Vierny's cinematography, the setting (actually a lavish palace outside of Munich), the impeccable wardrobe for "A" by Coco Chanel, and the endless intrigue of Seyrig's character. As the director, Alain Resnais, said of this film, "Each spectator can find his own solution, but it won't be the same solution for everyone."

Directed by Alain Resnais, 1961
Starring Delphine Seyrig, Giorgio Albertazzi, and Sacha Pitoëff

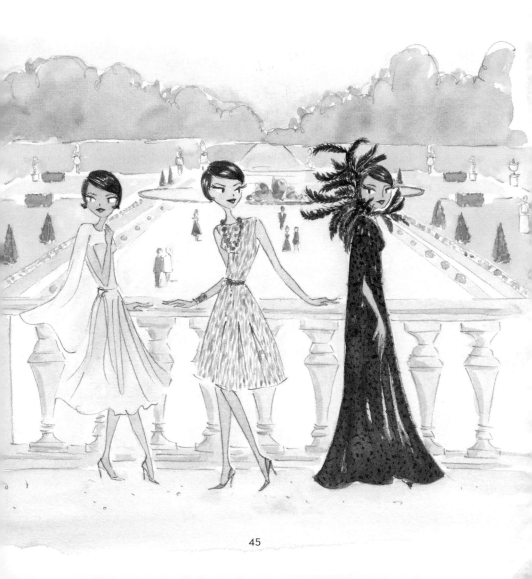

Photo taken by "X" of "A"

Shooting targets

The hotel Marienbad

Playing cards for the game Nim

Matchsticks for the game Nim

The guests at the hotel

Lola
(LOLA)

Lola, Jacques Demy's first film, is about chance encounters and a first love that is hard to shake. It takes place in the port city of Nantes and, similar to its French New Wave brethren, was shot entirely on location and in black and white.

Roland, a directionless young man who recently lost his job, is browsing in a bookstore when he meets a lonely single mother, Madame Desnoyers, and her fourteen-year-old daughter Cécile. The young girl reminds Roland of his lost teenage love, also named Cécile, who is now a cabaret dancer raising a young son, Yvon, and who goes by the stage name Lola.

Later the same day, Roland happens to run into Lola. After fifteen years, he's still infatuated with her, but Lola's romantic feelings are only for Michel, the father of Yvon. She's been pining for Michel ever since he abandoned her and Yvon for America, where he retreated to, hoping someday to return a rich man. Lola has not been entirely lonely in the meantime. She occasionally keeps company with an American sailor, Frankie, but only because he looks like Michel and will ship out soon.

Roland continues his quest for Lola, but she and Yvon are leaving for Marseilles. When she tries to let him down gently by saying she wants to remain friends, Roland doesn't take it well. With their bags packed, Lola and Yvon are saying good-bye to her fellow dancers when a tall blond man—who may or may not be Michel—enters the club. Meanwhile, the young Cécile meets Frankie, and the two spend the day together at an amusement park. When it's time for Frankie to ship out, the smitten Cécile sadly says good-bye, and it looks like this story of lost love has come full circle.

Directed by Jacques Demy, 1961
Starring Anouk Aimée, Jacques Harden, and Marc Michel

Adieu Philippine
(ADIEU PHILIPPINE)

The chaotic and humorously energetic *Adieu Philippine* follows the story of Michel, a clumsy camera technician who is waiting to be called up to serve in the Algerian war. He meets best friends and aspiring actors Juliette and Liliane outside of the TV station where he works.

This film has a signature *Nouvelle vague* semi-documentary style to it, with scenes showing passersby either gawking right into the camera or rubbernecking the girls as they briskly walk the streets of Paris. The soundtrack lends a breezy quality to the proceedings, especially when Michel starts up a casual romantic relationship with Juliette *and* Liliane.

The young women attempt to keep everything light with Michel by pretending it doesn't matter whom he prefers, but inevitably the two become jealous of each other. A rivalrous banter between the women continues throughout the film and is amplified when a hilarious con-artist producer named Pachala enters the scene. He hires Michel to help him shoot one of his absurd commercials, but of course never pays him.

Soon Michel gets restless with his job, the nettlesome girls, and the underlying threat of going to war and decides to take off for a vacation in Corsica with a friend. Liliane and Juliette can't resist joining Michel and show up on the island pretending they want to help him get his money from Pachala. Predictably, the three are unsuccessful with the deadbeat Pachala and the trip (and film) turns out to be about enjoying life and facing the struggles of becoming an adult. When Michel finally leaves for the military, the three friends wave good-bye to one another while also bidding *adieu* to their fleeting youth.

Directed by Jacques Rozier, 1962
Starring Jean-Claude Aimini, Stefania Sabatini, and Yveline Céry

Cléo de 5 à 7
(CLEO FROM 5 TO 7)

Cléo de 5 à 7 is director Agnès Varda's first film. As a trained photographer, Varda creates striking compositions and infuses lushness into the black-and-white world of the story—a gray zone of immorality all its own. The phrase "5 to 7" refers to the time when lovers, usually married men, meet with their mistresses.

The main character, Cléo, a beautiful, childish, and very superstitious pop singer, desperately waits on the results of medical tests that will (in her mind) confirm she's dying from cancer. As she's wallowing in self-pity, Cléo's "5 to 7" lover shows up at her loft apartment, staying only briefly and denying her the sympathy she craves. When her friends, a composer and piano player, also make light of her situation, Cléo walks out in a huff to seek solace elsewhere.

Her ongoing search for comfort seems futile, especially after she walks into a café, selects one of her own songs on the jukebox, and painfully overhears someone criticize her performance. Frustrated, Cléo decides to visit a girlfriend, Dorothee, who is modeling for an art class. She shares her grim medical condition and happily receives the sympathy she's longed for, but when Dorothee drops and breaks a compact mirror, Cléo instantly returns to doom and gloom.

Finally, Cléo heads for the park to be alone. It doesn't take long for her to meet Antoine, a soldier, who gladly shares his philosophy about life and war. They spark an instant connection and he helps bring out a Cléo who is genuine and humble, and he gives her the strength to accept the news of her illness, regardless of the outcome.

Directed by Agnès Varda, 1962
Starring Corinne Marchand, Antoine Bourseiller,
and Dominique Davray

Chapitre 1
CLÉO de 17 h. 05 à 17 h. 08

Jules et Jim
(JULES AND JIM)

Jules et Jim is one of the most revered films in all of French cinema. Best friends and soul mates, Jules and Jim share the same interests in art and literature, but whereas Jim is confident and a ladies man, Jules is insecure and struggles to find the right woman. When they both meet and fall in love with Catherine, whose passion and joie de vivre produce an immediate attraction, her constant need for attention eventually tests their friendship.

Jules begins to see Catherine exclusively, and after a few weeks he invites Jim over to become reacquainted with her. An anxious Jules has only one request: "Not this one, Jim, all right?" and Jim agrees. The threesome become inseparable, but Jules marries Catherine, takes her to Austria right before the war breaks out, and both men are called up to serve on opposing sides. (Here, in a perfect example of New Wave technique, the director shows the brutality of battle by using actual footage from World War I-era newsreels.)

Eventually, Jules returns from the war, and he and Catherine have a daughter, Sabine, but their marriage is miserable. Later Jim rejoins them and moves in with the unhappy couple. Jim obviously still harbors his long unfulfilled love for Catherine, and because Jules doesn't want her to leave him, he consents to an open affair between his wife and his best friend. In a constant struggle to find happiness, Catherine goes back and forth between her affection for Jim and for Jules, and even for a neighbor, Albert. When Jim moves on to another woman and Jules becomes complacent, she comes up with a plan that will hopefully end her discontent, regardless of the consequences.

Directed by François Truffaut, 1962
Starring Jeanne Moreau, Oskar Werner, and Henri Serre

Vivre sa vie
(MY LIFE TO LIVE)

Vivre sa vie opens with the credits flashing across varying close-ups of Nana, an aspiring actress who decides to leave her husband and child. When she can't find any acting jobs and her money runs out, she turns to prostitution. Stylistically, this film is different from director Jean-Luc Goddard's previous work because of its creatively composed extreme close-up shots and the fact that the scenes are broken up into twelve "chapters."

Nana, played by Anna Karina, the director's wife, wears a Louise Brooks black bob and is beautifully luminescent, but she seems devoid of the spirit she once had because of the demeaning life she's chosen to lead. Taking the advice of a friend, Nana begins to work for Raoul, a pimp who meticulously teaches her the tricks of the trade to ensure she'll become a reliable moneymaker.

At a café trying to drum up business, Nana sits across from an older gentleman and engages him in a discussion of the art of expressing oneself. This is the only moment that Nana is taken seriously, and it proves to be the highlight of the film. One lesson the man explains to Nana is that we must "pass through error to arrive at truth"—to learn from our mistakes. The conversation is an eye-opener for Nana, who has recently fallen in love with a man and wants to leave the degrading world of prostitution to start a new life. However, what was once a lifestyle choice that was supposed to set her free has become a force that she can no longer control.

Directed by Jean-Luc Godard, 1962
Starring Anna Karina, Sady Rebbot, and André S. Labarthe

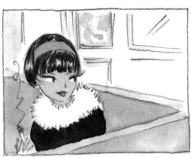

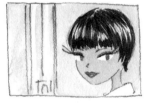

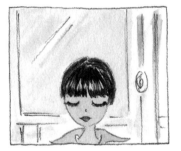

La baie des anges
(BAY OF ANGELS)

Platinum blonde Jackie Demaistre—impeccably dressed in white Pierre Cardin—is an all-in gambler who has happily found her lucky charm: Jean, a young bank clerk from Paris on vacation in Nice. They both bet and win on number 17 at Jackie's favorite spot, the roulette table, and the two find an immediate connection. Jackie nonchalantly shares that she has a child she never sees, and one can only wonder whether she gambled him away.

When the intoxicating piano arrangement fires up in Michel Legrand's musical score, it's obvious Jackie and Jean have won big, and soon the high rollers leave the Bay of Angels in Nice and head to glamorous Monte Carlo. Their luck, of course, takes a downturn, and Jean, who is willing to walk away from the tables, wants to return to Nice. Jackie, claiming she "doesn't like money," couldn't care less if she's gazing from the balcony of a ritzy five-star hotel or sleeping in a cold and dirty train station. Whatever it takes, she wants to play her last chip. Almost broke, the pair finally return to Nice, where Jean professes his love for Jackie. He wants to rescue her from her destructive obsession and take her home to Paris, but it's a crapshoot whether Jackie will go with him or stay behind to find her true love—the sound of the little white ball dropping into the winning slot.

Directed by Jacques Demy, 1963
Starring Jeanne Moreau, Claude Mann, and Paul Guers

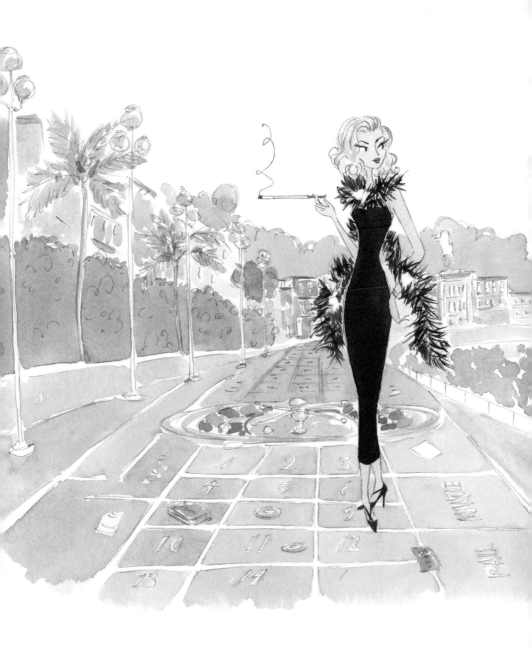

A split bet

Roulette wheel

Jackie's suitcase
filled with cash

Casino Monte-Carlo

Endlessly smoked
Lucky Strike cigarettes

Jackie's cigarette holder

Jackie's corselet

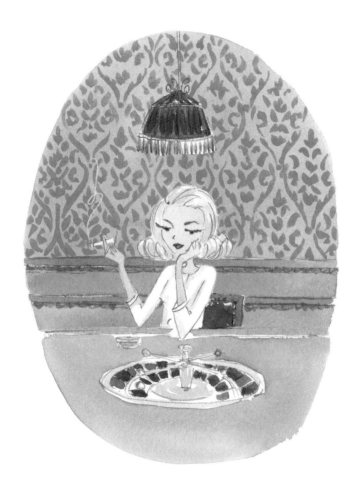

Jackie placing bets at the roulette table

Le mépris
(CONTEMPT)

Living in Rome, Parisian playwright Paul Javal is hired to "liven up" a script for a new movie adaptation of *The Odyssey*. On the first day of the project, Paul invites his wife, Camille (played by Brigitte Bardot), to visit the set, but as soon as she arrives, the troubles begin. A vulgar American producer, Jeremy Prokosch (American actor Jack Palance), asks the crew to join him at his villa and offers to take just Camille in his red two-seater sports car. It's clear Camille does not want to be alone with Prokosch, but when she tells Paul she prefers they get a cab and go together, Paul brushes her off, says she should go with Prokosch and that he'll take a cab on his own. When Paul is delayed in catching up with them, an annoyed Camille begins to sense her husband is using her to strengthen his professional relationship with Prokosch. Francesca, the attractive assistant who stays behind with Paul, doesn't help matters either.

Paul and Camille return to their apartment and begin an argument that takes up about thirty minutes of the film. Camille is so disgusted by the "crazy" producer and Paul that she begins to have doubts about their marriage. Paul, too, questions why he married the much younger ex-typist Camille. The dialogue of this scene is written and performed so realistically, it's easy to forget that Bardot and Palance are only acting.

The fighting continues when shooting of *The Odyssey* begins on the picturesque island of Capri. Camille catches Paul flirting with Francesca, so she deliberately kisses Prokosch, timing it perfectly so that Paul will catch them. The breakdown of the relationship between husband and wife continues, and where Camille once had respect for her husband, she now only has "contempt."

Directed by Jean-Luc Godard, 1963
Starring Brigitte Bardot, Jack Palance, and Michel Piccoli

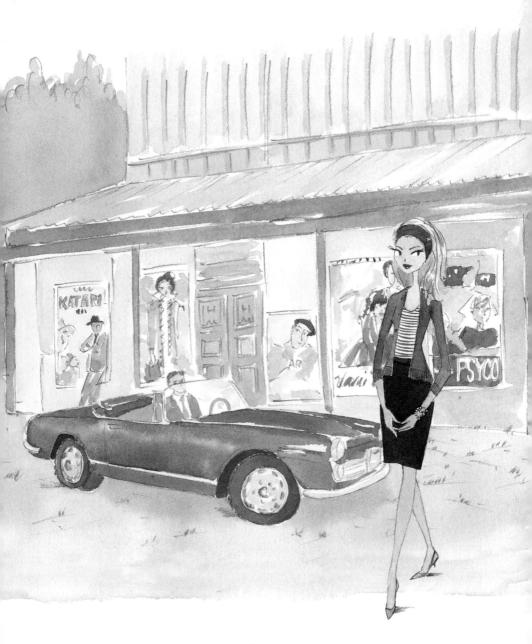

La peau douce
(THE SOFT SKIN)

When smoking was still permitted on airplanes, passengers would extinguish their cigarettes in ashtrays built in to the armchair. That's what the famous literary editor Pierre Lachenay is doing when he first glimpses Nicole, a gorgeous flight attendant. She appreciatively notices him leering at her, and it's obvious this married man and more-than-interested woman are on their way to an affair.

It's unclear why the uptight and elitist Pierre would cheat on his loving and attractive wife, Franca, with whom he has an adorable little girl, Sabine. Perhaps he wonders why the much younger and sensuous Nicole is attracted to him in the first place. She appears to be smitten, and when Pierre agrees to speak at the screening of a film in Reims, an hour outside of Paris, he takes Nicole with him.

What starts out as a carefree excursion quickly turns complicated. Nicole needs to stay hidden because of Pierre's associates, and when he doesn't leave a ticket for her at the event, she's left wandering the streets at night waiting for him to finish a drink with the organizer of the screening. When they finally do meet up, Nicole is upset, and they decide to head back to Paris in the middle of the night but stop at a small hotel on the way. There, Pierre checks in with Franca, who makes it very clear to him that she is aware of his infidelity. Pierre quickly realizes he doesn't have what it takes to carry on an affair, and Nicole can sense things are going to end badly, so she breaks off their arrangement. Meanwhile, a furious Franca comes up with a way to get back at Pierre, and it's a plan no one expects.

Directed by François Truffaut, 1964
Starring Jean Desailly, Françoise Dorléac, and Nelly Benedetti

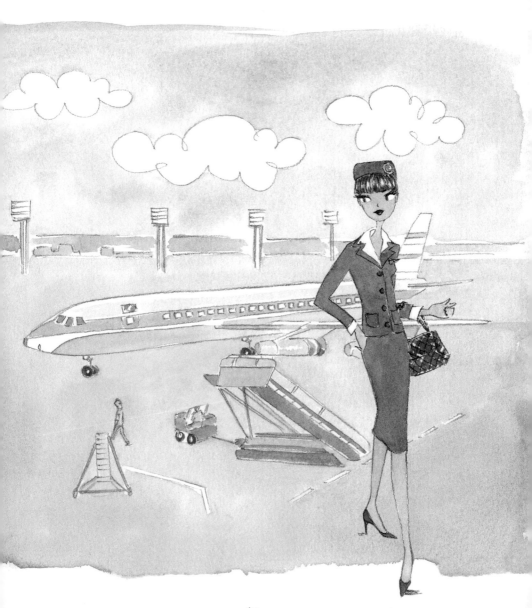

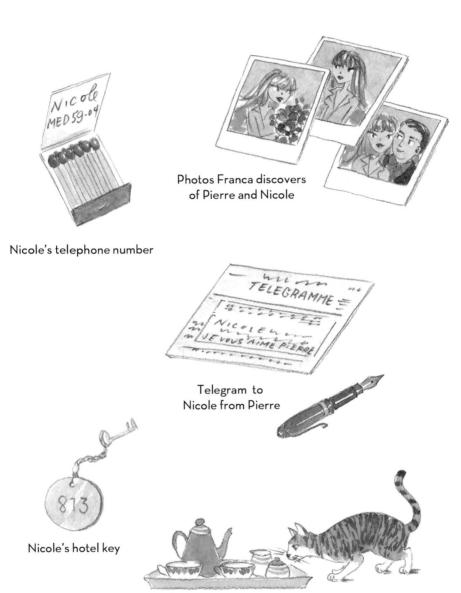

Nicole's telephone number

Photos Franca discovers
of Pierre and Nicole

Telegram to
Nicole from Pierre

Nicole's hotel key

Cat outside Nicole and Pierre's hotel room

Pierre secretly calling Nicole

Les parapluies de Cherbourg
(THE UMBRELLAS OF CHERBOURG)

Les parapluies de Cherbourg is one of the most romantic musical films of all time. The movie is operatic in conception, and the dialogue is sung throughout. The musical score starts out jazzy and upbeat, and the décor follows suit, with bright candy-colored sets.

Catherine Deneuve stars as Geneviève, a breathtaking beauty working in an umbrella shop owned by her protective mother, Madame Emery. Guy, her devoted boyfriend, fixes cars at the local auto mechanic shop. Geneviève and Guy are deeply in love and want to get married, but Madame Emery forbids it, insisting that her daughter is too young.

Meanwhile, the financially strapped Madame Emery is in danger of losing her shop, so she decides to sell her pearls at the local jewelry store, where mother and daughter meet Monsieur Cassard, a wealthy gem dealer. Cassard is immediately taken with Geneviève and is more than happy to help her and her mother.

As the Algerian war rages, Guy is drafted and marches off to join his military comrades, but not before the sweethearts consummate their love. Soon after, Geneviève discovers she's pregnant. Cassard swoops in and proposes, promising to raise the child as his own.

A few years later, Guy returns home from the front lines to find the umbrella shop has been sold and Geneviève is married. He goes through a rough patch of drinking but is eagerly rescued by Madeleine, his aunt's caretaker. The two marry, have a son, and after a few years, they buy the mechanic's shop. Around the same time, Geneviève drives through town and unknowingly pulls into Guy's shop to get gas. The two are surprisingly and unhappily reunited. Even though lost love rained on their passionate parade, singing through their misery actually makes it a bittersweet joy to behold.

Directed by Jacques Demy, 1964
Starring Catherine Deneuve, Nino Castelnuovo, and Anne Vernon

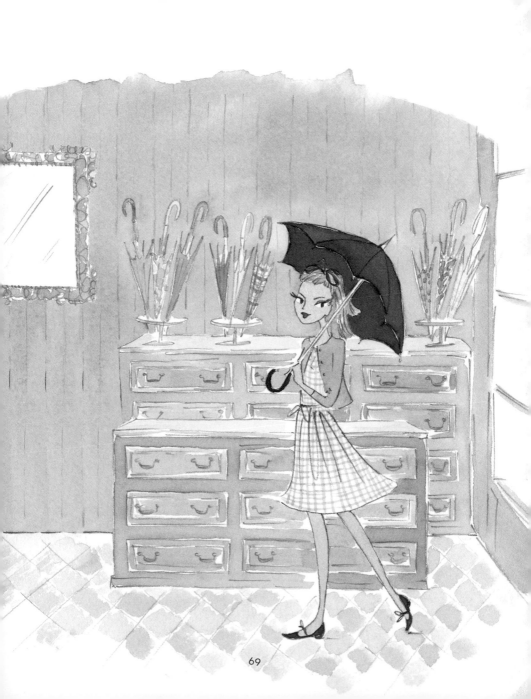

A photo of
Guy in Algeria

Paper crown M. Cassard
gives to Geneviève

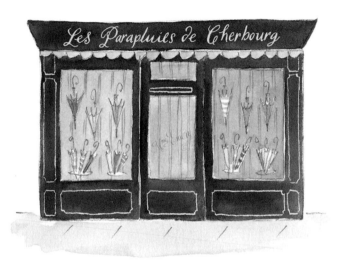

Mme Emery's Umbrella Store

Mme Emery's pearls she sells
to save her store

Umbrellas from
Mme Emery's store

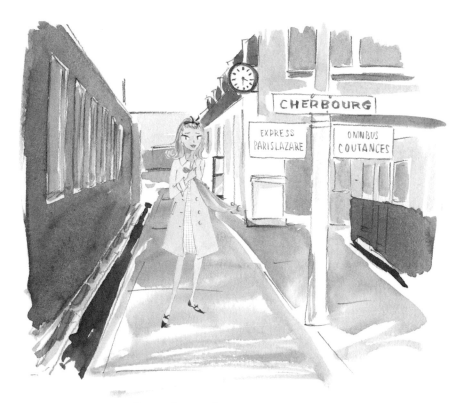

Geneviève at the train station
as Guy leaves for the military

Une femme mariée
(UNE FEMME MARIÉE)

Charlotte is a pretty and bored housewife married to Pierre, an airline pilot. She bounces back and forth between her husband and a lover, Robert. The film opens with beautifully composed close-ups of Charlotte and Robert caressing each other in a hotel room—Charlotte's hand reaching out wearing a wedding ring, Robert's hand without a wedding ring grasping Charlotte's wrist, and Charlotte's legs roaming across the bed. These movements continue without real emotion and begin to resemble the print advertisements Charlotte obsesses over in her fashion magazines.

As Charlotte carries on her carefree bourgeois life of shopping, attending fashion shows, fixating on the size of her breasts, and meeting her lover, she discovers she is pregnant. She keeps this information a secret from Robert—perhaps not knowing if it's his. It's hard to tell whether Charlotte even wants a baby, but flipping through the glossy pages of Paris *Elle* may just give her the answer she's looking for.

The French censorship board stirred up controversy over the title of this film, forcing director Jean-Luc Godard to change it from "*The* Married Woman" to "*A* Married Woman" because the former seemed to imply that all married French women were like Charlotte. Though perhaps not intending to take aim squarely at French women, Godard did say he hoped to make a larger commentary on youth culture of the mid-1960s, a generation he observed as being more absorbed by TV and fashion than by important world events. The director addressed this indifference on the screen. For example, during a dinner party at Charlotte's home, she gets into a debate about the past and the present and insists she prefers the present because "there's no time to think."

Directed by Jean-Luc Godard, 1964
Starring Macha Méril, Bernard Noël, and Philippe Leroy

Triumph

La petite **Scand**

Pierrot le fou
(PIERROT LE FOU)

Ferdinand, a family man who decides to leave his shallow life in Paris, runs away with Marianne (played by Anna Karina, the director's soon-to-be ex-wife), his former girlfriend and the family babysitter, in hopes of finding a life of adventure and freedom from a materialistic society. However, he quickly discovers Marianne has murdered a man, is running from the OAS (a counterterrorist organization), and is an excellent liar.

The story is not an easy one to follow, especially with the unexplained scenes, such as when Marianne strolls through the apartment cheerfully singing and then, when the camera pans out, a dead body appears. However, the dynamic of the couple is entertaining to watch, especially as they perform one crazy antic after another. One escapade has them on a crime spree involving a stolen car. Ferdinand decides to drive the vehicle into the ocean and leaves it there. After hiding in Saint-Tropez, the lovers' relationship becomes strained, and Marianne convinces Ferdinand to return to the city, but her crooked past catches up with her and the two are separated. When they reunite, Ferdinand is suspicious and realizes she's been using him to get back a suitcase full of money that she stole from the OAS gangsters. Tiring of Marianne, he puts a fatal end to her double-crossing and deceit.

Pierrot le fou received dreadful reviews upon its release, but eventually, critics changed their minds and gave it high praise for its unusual nature. One famous example of the film's innovative style is a party scene shot in varying monochromatic tones. Ferdinand walks from one mundane conversation to the next and eventually meets an American director who actually has something meaningful to say. As the filmmaker speaks, the room suddenly changes to full color. This unexpected moment, and many more, keep *Pierrot le fou* a rollercoaster ride from start to finish.

Directed by Jean-Luc Godard, 1965
Starring Anna Karina and Jean-Paul Belmondo

One of Marianne's
murder weapons

One of the exotic pets
the couple has
in the French Riveria

Children's book that Ferdinand
has with him at all times

Marianne's dress used
to water board Ferdinand

Bucket of paint Ferdinand
uses to paint his face blue

Stuffed animal Marianne
carries with her everywhere

A car Marianne and Ferdinand
steal before an oil change

Le bonheur
(LE BONHEUR)

Life couldn't be happier for François, Thérèse, and their two small, adorable children. The couple (played by Jean-Claude Drouot and Claire Drouot) exist in a dizzyingly idyllic marriage. From the small town of Fontenay, they head to the country every Sunday for a delightful day trip of picnicking and dreamy naps. The backdrop of the film starts out with a display of yellow and orange flora and proceeds through brightly tinted fade-outs that dissolve from one scene into the next, reflecting the sunny nature of François and Thérèse's marriage.

François is a carpenter working for his uncle, and Thérèse is a seamstress who takes in odd jobs from the townspeople. When François is asked to go on a business trip to Vincennes, he meets Émilie, a beautiful postal employee, and instantly falls in love with her. The two begin an affair, and François is the happiest he's ever been. Thérèse begins to notice a difference in his mood, and when she inquires about it, François—who prides himself on being truthful—can't stomach the thought of lying to his wife. He comes clean that he is in love with another woman; however, François explains that he loves them both equally and, if Thérèse gives her blessing, he would like to continue romancing Émilie while remaining married. Thérèse agrees to this one-sided plan, noting that if François is happy, she is happy. But this serene film suddenly turns dark when François tragically loses the mother of his children. His grieving period is brief and it's curious to watch him happily move on when Émilie eagerly takes his wife's place.

Directed by Agnès Varda, 1965
Starring Jean-Claude Drouot, Claire Drouot,
and Marie-France Boyer

Belle de jour
(BELLE DE JOUR)

Séverine, the exquisitely beautiful but seemingly frigid housewife of a handsome surgeon, Pierre, has an erotic fantasy life that quickly becomes a reality. After hearing about a high-class brothel that employs mostly wives looking to make a little extra cash while their husbands are at work, she can't resist checking it out. Upon meeting the impeccably dressed Séverine, the owner, Madame Anaïs, immediately knows she has just found someone special. Séverine, now going by the name "Belle de jour," is shy and disgusted at first, but soon realizes she's free to carry out her fantasies in real life.

As Séverine's double life plays out, she starts a relationship with a customer named Marcel, a reckless thug with hideous metal teeth who falls in love with her. She has no real affection for him but finds his crude bad-boy behavior irresistible, especially when she compares him to her dull and undersexed husband. When Marcel becomes jealous of Pierre, he makes a move that could be life-changing for Séverine—or is her imagination creating another daydream to quench her thirst for excitement and adventure?

Catherine Deneuve, who plays the part of Séverine, claimed she was unhappy with the more risqué parts of the film. This signature role shifted her screen persona from sweet and innocent to iconic ice queen. And for the director, Luis Buñuel, *Belle de jour* became his most successful movie, one that once seen proves unforgettable.

Directed by Luis Buñuel, 1967
Starring Catherine Deneuve, Jean Sorel, and Michel Piccoli

Les demoiselles de Rochefort
(THE YOUNG GIRLS OF ROCHEFORT)

Director Jacques Demy followed up his musical *The Umbrellas of Cherbourg* with a song-and-dance feature, *Les demoiselles de Rochefort*. In it, real-life sisters Catherine Deneuve and Françoise Dorléac play twins Delphine and Solange, who give music and dance lessons to the local children. Both women long to leave their small seaside town in search of true love, fame, and fortune. When a carnival comes to town, it looks as though their tiny world is about to get a lot bigger.

This delightful film is full of candy-colored costumes, elaborate dance numbers, and missed encounters. Though the movie is definitely French, it's reminiscent of Golden Age Hollywood musicals, especially with the American actor and dance legend Gene Kelly in the cast.

In addition to its breezy quality, *The Young Girls of Rochefort* keeps viewers on their toes with its offbeat storyline. For instance, the twins' mother, Yvonne, pines for a fiancé she left years ago because his name was Simon Dame, which would have made her Madame Dame. Meanwhile, Delphine sees a painting in a gallery that resembles her and wants to meet the artist, Maxence, who calls his artwork the "feminine ideal." As the singing and dancing continues, two performers talk Delphine and Solange into performing at the carnival. The sisters agree, and when they finish their trial number to a roaring round of applause, they're invited to join the traveling group. On the day of departure, Solange is a no-show and Delphine anxiously decides to leave without her. By coincidence, Maxence is discharged from the army and decides to hitch a ride with the performers. Delphine, just a few cars back, has no idea that the man she longs to meet could be part of an adventure she's always dreamed about.

Directed by Jacques Demy, 1967
Starring Catherine Deneuve, Françoise Dorléac, and George Chakiris

Painting of Delphine,
as the "feminine ideal"

Solange's
concerto

Square where thousands of shutters
were repainted in pastel colors

A few of Solange and
Delphine's many hats

Delphine and Solange perform at the town's festival

Le samouraï
(LE SAMOURAÏ)

Wearing his signature fedora and khaki trench coat, the handsome assassin Jef Costello walks expressionless into a nightclub, pulls on his white gloves, draws his gun, and shoots the owner. At least five witnesses see him rush out of the club. When the police question them, one gentleman says Costello is the shooter; three others can't be sure; and Valerie, the piano player, lies and claims she's positive he was not at the club. Costello is puzzled why she's not telling the truth, but he has an airtight alibi: Jane, his lover, who is certain not to crack under police threats.

Living alone in a gray, gloomy apartment with little more than a pet bird and stacked bottles of Evian, Costello discovers the police have bugged his room. Meanwhile, the bad guys who hired him have lost trust in him after his run-in with the authorities; yet he is still offered a new contract—one that is complicated. When the police realize Costello has found the bug, they decide to tail him, which leads to an exciting game of cat-and-mouse through the underground Paris Métro.

As Costello reaches the destination of his next hit, he keeps the audience guessing as to who will be his target. No matter the consequences, he must stay on task and always stay true to the way of the Samurai.

Le samouraï is considered director Jean-Pierre Melville's masterpiece; it was a box-office hit and a major influence on directors for decades to come. Sex symbol Alain Delon plays Jef Costello with a chill that's as icy as his haunting cerulean blue gaze. Between Delon's performance and the sparse dialogue—used only when absolutely necessary—the film has a tense quality that keeps your eyes glued to the screen.

Directed by Jean-Pierre Melville, 1967
Starring Alain Delon, Nathalie Delon, and François Périer

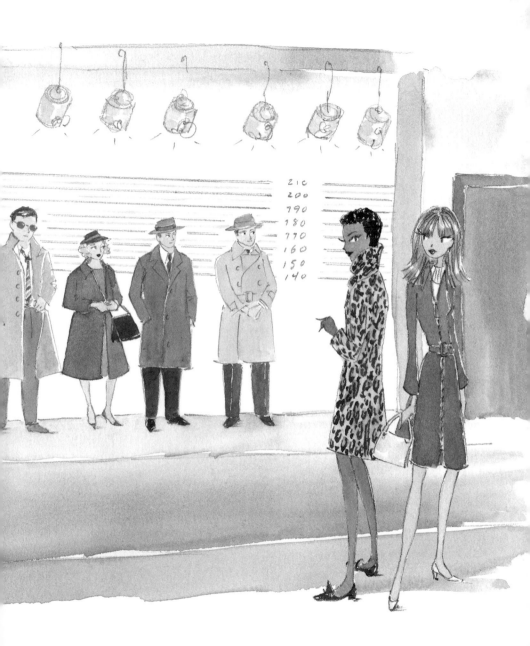

210
200
190
180
170
160
150
140

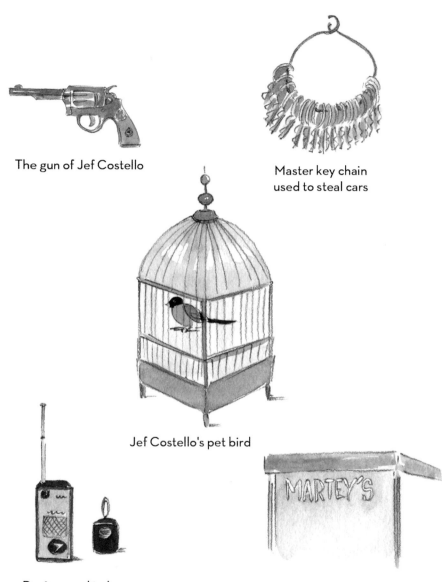

The gun of Jef Costello

Master key chain
used to steal cars

Jef Costello's pet bird

Device used to bug
Jef Costello's apartment

Entrance to Martey's nightclub

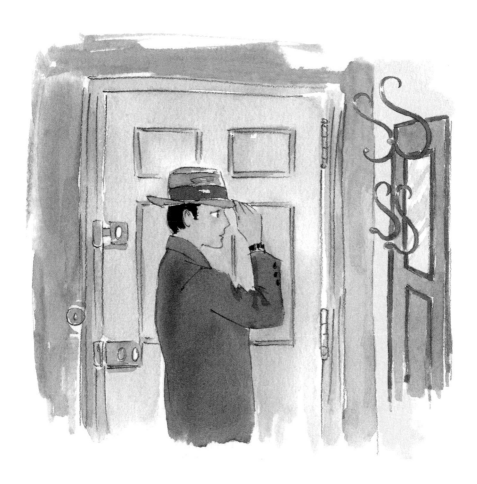

Jef Costello meticulously
adjusting the brim of his fedora

La collectionneuse
(THE COLLECTOR)

La collectionneuse is the third of a six-film series by director Éric Rohmer titled "Six Moral Tales." Each entry in the series involves a man choosing between two women from different social backgrounds and ending up with the "right" one. Because of budget constraints, Rohmer hired nonprofessional actors for *La collectionneuse* and the cast wrote most of the dialogue.

In this story, Adrien, an art collector, and his artist friend Daniel are invited to spend a peaceful summer at their friend's villa above the hills in Saint-Tropez. The self-assured Adrien wants to spend his days "doing nothing," and Daniel, a volatile sculptor, is looking for a much-needed break from his artistic endeavors. However, a young and tempting doe-eyed woman, Haydée, receives the same invitation, and the two men are not happy about the presence of this unexpected roommate.

The free-spirited Haydée goes about her business, enjoying the nightlife in town and quickly earning the nickname "The Collector," bestowed by her judgy new housemates because she brings home a new lover almost every evening. Haydée claims she is not a "slut" but rather is searching for real love. Despite their disapproval of Haydée, Adrien and Daniel silently desire the young woman and wonder who will get to sleep with her first. Much to their frustration, Haydée maintains the upper hand, and the men's desire to do nothing quickly becomes a longing to doing anything with a beauty who eludes their grasp.

Directed by Éric Rohmer, 1967
Starring Haydée Politoff, Patrick Bauchau,
and Daniel Pommereulle

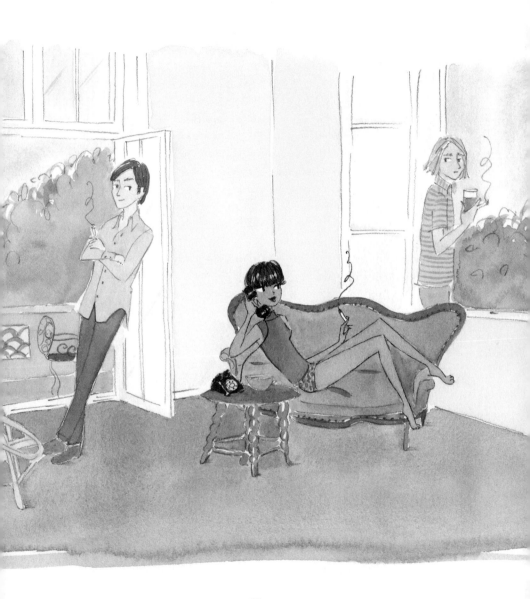

La femme infidèle
(THE UNFAITHFUL WIFE)

Hélène and Charles appear to be a content upper-class couple. They have a handsome little boy and a lovely home near Versailles. However, the beautiful and bored Hélène (played by Stéphane Audran, the director's wife) appears restless and is having an affair with a writer who lives in Paris. Mild-mannered husband Charles starts to suspect what his wife is up to and has her followed by a private detective.

When the affair is confirmed, Charles visits the apartment of his wife's lover, Victor. When Charles lies about he and his wife having an open marriage, Victor reluctantly lets him in. Charles requests a tour of Victor's flat. When he sees the unmade bed, he's unable to mask his anger and impulsively grabs a ceramic Nefertiti bust and strikes Victor over the head with it, instantly killing him. Oddly, this is the only time Charles loses his cool; he even remains calm as he proceeds through the steps of disposing of Victor's body.

Charles never confronts Hélène about her affair, and when she doesn't hear from Victor, they both pretend as if nothing has happened. But tension starts to build in this once-idyllic home and eventually the police show up to question the couple about the disappearance of Victor. They both deny any real connection to the victim, but it becomes obvious they are covering for each other.

Toward the end of the film, Hélène accidently discovers and destroys a piece of evidence that proves Charles killed Victor. Soon after, she walks outside to join her husband in the garden, and in one of the most memorable moments of the film she delivers a discreet, knowing smile, revealing that she knows Charles would do anything for her, even murder.

Directed by Claude Chabrol, 1969
Starring Stéphane Audran, Michel Bouquet, and Maurice Ronet

Baisers volés

(STOLEN KISSES)

Baisers volés is a comical third sequel to director François Truffaut's *Les quatre cents coups* and *Antoine et Colette*, which follow the character Antoine Doinel. Here, Antoine is given a military dishonorable discharge because he is "temperamentally unfit for service." He heads home to reunite with his on-again, off-again girlfriend Christine, a violinist who lives with her parents. Christine is apprehensive about starting up with Antoine again, especially because his letters turned nasty when she wasn't writing back fast enough.

With the help of Christine's father, Antoine finds employment as a night clerk at a seedy hotel. However, the inept Antoine gets canned after his first night because he lets a private detective and a suspecting husband into one of the hotel rooms, where they find the man's wife in bed with another man. But meeting the detective leads to a job with the Blady Detective Agency for Antoine. In his new vocation, he goes undercover as a stock boy in a shoe store. The shop owner, Monsieur Tabard, wants to know why his employees, wife, and almost everyone he knows detest him. After meeting the owner's flirtatious wife, Madame Tabard, Antoine is love-struck because she is his "ideal" woman. When they're alone together, he's so nervous he spills his coffee, calls her "Monsieur," and then sprints out of the room.

Antoine and Madame Tabard have an unlikely, brief affair, because Antoine confesses about the tryst to his boss and gets fired once again. But another job as a TV repairman opens up. Christine, who wants Antoine back, intentionally dismantles her TV and calls his company for a repairman. Antoine is sent over and, though the TV never gets fixed, the two rekindle their love and Antoine discovers Christine is truly his "ideal" woman.

Directed by François Truffaut, 1968
Starring Jean-Pierre Léaud, Delphine Seyrig, and Claude Jade

Newspaper Antoine uses
to hide behind while
investigating a subject

Notes between
Antoine and Christine

Antoine's English
lesson records

Antoine's love and farewell
letter to Madame Tabard

The Blady Detective Agency

Antoine attempting to fix Christine's TV

Le grand amour
(LE GRAND AMOUR)

Le grand amour is a playful film directed by and starring filmmaker, musician, and illustrator Pierre Étaix. The delightful proceedings are full of gags and slapstick stunts that—without the help of modern-day computer-generated imagery—seem near-impossible to have been pulled off in 1969.

The movie opens with a young couple, Pierre and Florence, about to be married. A reluctant Pierre reflects on his romantic past, and as he lists previous girlfriends in his head, he's suddenly shown kneeling next to a row of ten potential brides who could have been his wife. Nevertheless, Pierre and Florence do get married and he takes an executive job at his father-in-law's tannery. Their monotonous bourgeois married life wears on Pierre, but things look up when a lovely young trainee, Agnès, is hired to replace his secretary. Pierre is besotted with her, and when he dozes off at night, he dreams of them snuggling together in a motorized rolling bed as they cruise the countryside, passing other mobile beds that have either broken down or crashed into each other.

One evening, to Pierre's delight, Florence tells him she wants to vacation alone on the coast. Seeing an opportunity to pursue Agnès, Pierre invites the young woman out for a romantic dinner. Agnès quickly becomes bored as he drones on and on about work and—in a clever sight gag—he progressively gets older every time the camera cuts to him. Pierre realizes their age difference is too great for a lasting relationship and decides he's happy enough with his wife. But when Florence returns, she has a surprise that Pierre never saw coming.

Directed by Pierre Étaix, 1969
Starring Pierre Étaix, Annie Fratellini, and Nicole Calfan

Au hasard Balthazar
(AU HASARD BALTHAZAR)

A certified masterpiece among cinephiles, *Au hasard Balthazar* is a heartbreaking story described by the director as "the world in an hour and a half." The two main characters are Balthazar, a donkey, and Marie, a young farmer's daughter, who is Balthazar's first owner. Balthazar, who lives to serve others, is passed along from owner to owner and endures cruel treatment from hand to hand. Marie, who unlike Balthazar can choose her own company, nevertheless finds herself attracted to a vicious small-town punk, Gérard, who abuses both her and Balthazar throughout the film.

The highly regarded director, Robert Bresson, a Catholic, was known for his spiritual-themed film work. From Balthazar's baptism by Marie to his wearing a garland of daisies not unlike a crown of thorns and his eventual "canonization" as a saint by Marie's mother, many viewers have noted religious undertones in *Au hasard Balthazar*.

Stylistically, the nonprofessional actors were required to perform in an almost robotic manner that Bresson believed would deliver pure performances. He feared trained actors would add their interpretation and change the meaning of the story. Empathy is a key emotion in the film, and it's impossible not to feel Balthazar's misery as he goes from one oppressive owner to another. When he's fatally shot after Gérard is caught using him to smuggle stolen goods across the border, he finally finds solace in a field surrounded by a herd of sheep and away from the people who caused him so much pain.

Directed by Robert Bresson, 1966
Starring Anne Wiazemsky, Walter Green, and François Lafarge

Les choses de la vie
(THE THINGS OF LIFE)

Driving across the French countryside, chain-smoking engineer Pierre Bérard swerves off the road. While careening into a field, he drifts in and out of consciousness and reexamines his life leading up to the accident. The flashbacks explain his complicated life with Hélène, his adoring mistress, and Catherine, his accommodating yet estranged wife.

Pierre and Hélène are supposed to move to Tunis for a job that he's been offered, but when she reminds him he needs to sign the documents, he unexpectedly tells her they'll have to wait because he's going to take his son on holiday. The two argue, and on his drive to meet his son, he stops to write a letter to Hélène telling her he wants to break off their affair. But he stops short of mailing the note.

Concurrently, details of the car crash are dramatically revealed, with the car flipping over and over, the windshield smashing, and cigarettes tumbling out of Pierre's pocket. The scene is first played out in slow motion and then suddenly is shown in real time, with Pierre violently thrown from the car.

Finally, Pierre is taken to the hospital, where he begins to hallucinate blissful scenarios, but the visions slowly turn bleak and disturbing. In the waiting room, Catherine is given Pierre's belongings, including the good-bye letter to Hélène, which she sympathetically tears up. Hélène sees Pierre's destroyed car while driving past the accident scene, rushes to the hospital, and desperately waits to hear whether the man she still loves will survive.

Directed by Claude Sautet, 1970
Starring Michel Piccoli, Romy Schneider, and Gérard Lartigau

Pierre's cigarettes
tumbling as the car flips over

Hélène's typewriter

Pierre's Alpha Romeo

Pierre surrounded
by Poppies after he's
thrown from his car

Hélène's glasses

One of Pierre's hallucinations

La nuit américaine
(DAY FOR NIGHT)

The title *La nuit américaine* comes from a technical term for the technique of using a filter on the camera lens to create a nighttime scene while shooting during the day. This is just one of the cinematic techniques described in this funny, tragic, and titillating feature about all the craziness that goes on while producing a movie.

François Truffaut directs and stars as Ferrand, the director of the film within a film, *Meet Pamela*, a scandalous tale of a young married couple in which the wife falls in love with her father-in-law. But what's happening behind the camera is where the real action is. There's Julie, who plays Pamela, the main character of the film within, who's about to lapse into a second nervous breakdown, and Alphonse, who plays Pamela's husband and who is desperately in love with a flighty script girl. Meanwhile, the aging alcoholic diva, Severine, can't remember her lines, and the elder leading man, Alexandre, is coming to terms with his sexuality.

Then there's the zany crew, who try to keep the cameras rolling while searching for props, forcing a kitten to hit her mark, and keeping temporary flings a secret. The passionate filmmaker Ferrand, who knows this flop won't win him any awards, is just patiently waiting to move on to his next cinematic adventure.

Ironically, *La nuit américaine* received four Academy Award nominations and picked up a win for Best Foreign Language Film. This movie is a tribute to cinema itself, giving viewers an appreciation of the mishaps, achievements, frustrations, and successes that make up the frenzied world of filmmaking.

Directed by François Truffaut, 1973
Starring Jacqueline Bisset, Jean-Pierre Léaud, and François Truffaut

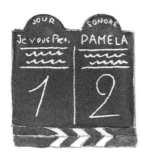

Clapboard

Tub of butter
to calm Julie

Severine's champagne

Wigs for Severine
and Pamela

Director's
reference books

Julie's director's chair

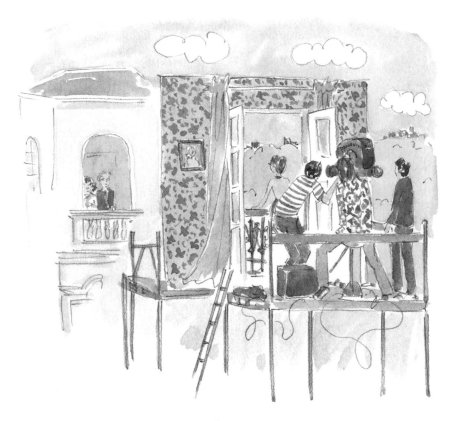

Hotel room set

Diva
(DIVA)

Jules is a young moped-driving mail courier living in Paris and obsessed with an American opera singer, Cynthia Hawkins. One evening, he secretly tapes a high-quality recording of the singer's performance just to have for himself. This is significant because the "Diva," as Cynthia is referred to, refuses to release an album because she believes she can't perform without an audience. Two Taiwanese gangsters seated behind Jules see him making the cassette, and even before they have the recording in hand they threaten to blackmail Cynthia with the bootleg tape unless she signs a recording deal with them. Meanwhile, a prostitute named Nadia, who has escaped a sex and drug-trafficking ring, drops an incriminating cassette into Jules's mailbag right before two crooked cops murder her.

While shopping in a record store, Jules meets Alba, a fellow opera enthusiast. He shares his recording of the Diva with her. She in turn plays the tape for Gorodish, the man she lives with in a huge industrial loft. The three become fast friends, which proves helpful for Jules because things begin to heat up with the good cops, bad cops, and mobsters all in hot pursuit of the tapes.

After Jules narrowly escapes in an exciting chase scene through the Métro with a legit cop who's after Nadia's tape, he's on the run again from two crooked cops who are after the same tape. Gorodish comes to his rescue, but Jules's troubles are far from over—he still is in possession of the recording of Cynthia, and he's determined to get it to her first, and persuade her to share the recording.

This slick feature started the *Cinéma du look* movement of the 1980s, where style took precedence over substance. *Diva* showcases this genre, with its elaborate chase scenes, sleazy law enforcement, and idiosyncratic young lead characters.

Directed by Jean-Jacques Beineix, 1981
Starring Wilhelmenia Fernandez, Frédéric Andréi, and Thuy An Luu

Tape recorder used to record
Cynthia's performance

Nadia's
incriminating recording

Jules' helmet

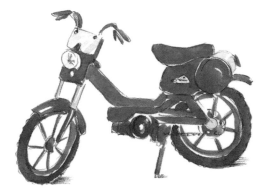

Jules's moped

Magic bird figurine

Gorodish's bathtub

Jules escaping the police
down into the Metro

Une chambre en ville
(UNE CHAMBRE EN VILLE)

Une chamber en ville, like several of director Jacques Demy's earlier films, features the characters singing every line of dialogue. The indoor sets are brightly colored, and the costumes of the key characters are in a pastel palette that makes them stand out against the monochromatic cityscape and the dirty indigo uniforms of the steelworkers who are a centerpiece of this story.

Set in 1955, the film opens with steelworkers striking in the streets of Nantes. François, one of the picketing metalworkers, rents a room in the home of Madame Langlois and is involved with a sweet young woman named Violette. The young couple appear to be in love, but the strike puts a damper on their lives. Meanwhile, Madame Langlois's rebellious daughter Edith is married to Edmond, a suffocating television shop owner, who, oddly enough, resembles a leprechaun. Edith cannot stand her husband and tortures him by walking the streets in a fur coat, wearing nothing underneath.

Following a fight with Edmond, Edith takes to the streets and hangs out in front of a hotel, where she encounters François, who's walking home after an evening at the bar. The two spend the night together and immediately fall in love. But the newfound romance is about to get complicated, not because Edith is married to a lunatic, but because poor Violette is pregnant. As the ongoing strike erupts again, the illicit love affair between François and Edith appears to head down a path reminiscent of that of Romeo and Juliet.

Directed by Jacques Demy, 1982
Starring Dominique Sanda, Danielle Darrieux,
Richard Berry, and Michel Piccoli

Delicatessen
(DELICATESSEN)

This surreal and stylistic dark comedy takes place in a postapoca-lyptic world, where Louison, an unemployed circus performer, has unsuspectingly answered an ad for a handyman in a dilapidated apartment building. Louison has no idea that his new boss—the land-lord as well as the town butcher—plans to serve him up as a meal for his meat-deprived tenants.

Thankfully, cannibalistic mayhem in the story takes a backseat to the entertaining antics of the colorful cast of characters living in the building. Among the eccentric individuals are a nervous Mrs. Interli-gator, whose tormenting inner voices egg her on to conjure up one creative, yet unsuccessful suicide attempt after another; the soggy Troglodytes, a vegetarian gang who live in the damp underground and rebel against the carnivores living upstairs; and Julie, the shy, love-starved butcher's daughter, who is perhaps the most "normal" resident in the menagerie.

The potential courtship between Julie and Louison is what makes this very dark film actually come across as sweet and charming. Trou-ble continues brewing behind their melodious romance, and soon they must devise a plan to save Louison from becoming the hungry neighbors' next entrée.

Directed by Marc Caro and Jean-Pierre Jeunet, 1991
Starring Marie-Laure Dougnac, Dominique Pinon,
Jean-Claude Dreyfus, and Pascal Benezech

Suicide scheme for Mrs. Interligator

One of the many snails
turned into escargot

Butcher shop sign

Frog living
underground

Julie's umbrella

The butcher's knife

Tea and bisquits from
Julie and Louison's first date

One of Louison's circus acts

Nikita
(LA FEMME NIKITA)

This action thriller revolves around Nikita, a feral drug addict who shoots and kills a police officer after a pharmacy robbery goes awry. Instead of serving her a life sentence, the French government fakes Nikita's death and trains her as an assassin. Her icy mentor, Bob, sees potential in the rebellious Nikita, but it takes three long years of training before she's ready for her role as a hit-woman. After finally completing her education in firearms, hand-to-hand combat, computer skills, and "femininity," she must pass one last test.

Outfitted in a little black dress and heels, an unsuspecting Nikita is presented with a beautifully wrapped package at a supposed birthday dinner with Bob. The gift turns out to be a gun, and her orders are to immediately kill a foreign diplomat seated a few tables away in the crowded restaurant. This scene turns into an exciting one-woman gunfight, where she takes out a dozen bodyguards, escapes down a garbage shoot, and safely returns to the agency.

Nikita passes her last test with flying colors and is allowed to rejoin society, but as a secret agent. While relishing her newfound freedom, Nikita meets a grocery clerk named Marco and falls in love with him. The two move in together and begin an idyllic life together, but it's short-lived because Nikita reluctantly takes on assignments that she conceals from Marco.

When Nikita takes a high-risk job to steal documents from an ambassador's office, mayhem ensues and she narrowly escapes a bloody shootout. The fear and the never-ending burden of this double life weigh heavily on her, and Nikita must decide whether she can go on living as a killer or go into hiding without her beloved Marco.

Directed by Luc Besson, 1990
Starring Anne Parillaud, Marc Duret, Patrick Fontana, and Jeanne Moreau

Glasses with
secret camera

Coffee cup with secret recorder

Nikita as an undercover
hotel employee

Nikita as an
undercover art dealer

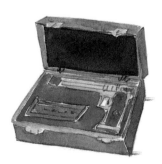

Weapon used
for Nikita's final test

Escape window opens
to a brick wall

Nikita transforming from misfit to secret agent

Le fabuleux destin d'Amélie Poulain
(AMÉLIE)

The mission in life of adorable doe-eyed waitress Amélie Poulain is to make people happy. Interpreted by the endlessly charming Audrey Tautou, Amélie finds a mysterious box hidden in the wall of her bathroom and tracks down the man who as a boy was its rightful owner. After seeing the delight in his face upon having the box returned, she sets out to devise whimsical plans to bring ever more people joy. Amélie goes on to give hope to a mopey, lonely lady in her building, guides a blind man through a street in Paris while narrating all that is happening around them, and helps a shy clerk get out from under the thumb of a nasty grocery owner.

Aside from the little pleasures she finds in life, like skipping stones, the feeling of sinking her hand into a bag of beans, and noticing the little things other people never see, Amélie seems to be masking her own lack of happiness. As a lonely and sheltered child, she developed an inventive imagination that carried over into her adulthood. To illustrate this, the film is filled with sweet and simple special effects, like when Amélie literally dissolves into a puddle of water because of a crush she has on the quirky Nino.

Amélie gets a nudge from a neighbor, who encourages her to be brave and to follow through with her feelings for Nino. Amélie finds one of Nino's arty photo albums, which he drops from his motorbike, and she cleverly lures him in to return it. After all the twists and turns, the kooky couple seem destined to begin an eccentric and dreamy love affair.

Directed by Jean-Pierre Jeunet, 2001
Starring Audrey Tautou and Mathieu Kassovitz

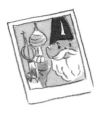

Polaroids® of the globetrotting Gnome
to encourage travel and adventure

The sound
of crème brûlée
cracking

Flat stones
for skipping

Nino's photo album

The hidden box of
treasures from
many years past

A lost love letter of hope

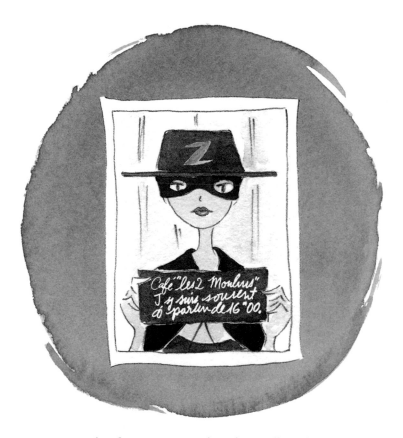

A clue for Nino to get his photo album back

The Artist
(THE ARTIST)

It's 1927 and the dashing George Valentin and his talented dog, Uggie, are Hollywood's biggest silent screen stars. After a premiere of their latest picture, George literally bumps into an aspiring and ambitious actress named Peppy Miller. Photos of her are splashed across the pages of *Variety*, and George helps her get a small part in his next film. As "talkies" take over Hollywood, Peppy's career climbs, but George, who refuses to take part in the new craze, gets left behind.

A stubborn George decides to write, direct, fund, and star in what will likely be the last silent film of the era. Two days after its release, the stock market crashes, the picture flops, and George finds himself bankrupt. After his wife, Doris, kicks him out, he moves into a dingy one-room apartment and auctions off all of his personal belongings. Depressed, George begins to watch his old silent films and then decides to set fire to them, but that leaves him trapped inside. Uggie manages to get help to rescue George from the blaze, and Peppy takes him in to recuperate. At her home, George discovers Peppy has bought everything he sold at auction, so he takes off in a rage. Peppy finds him before he does something irreversible and offers him a new career path. The has-been silent film star reinvents himself, and this time everyone is listening.

The Artist is a French film but was shot in the United States, fittingly, because it blends two classic American stories—that of *A Star Is Born* and *Singin' in the Rain*. The movie is "silent," with the exception of a dynamic musical score and a few clever bits of sound. It became an unlikely hit and cleaned up at the 2012 Academy Awards, winning awards for Best Picture, Best Actor (Jean Dujardin), and Best Director (Michel Hazanavicius).

Directed by Michel Hazanavicius, 2011
Starring Jean Dujardin, Bérénice Bejo, and John Goodman

ACKNOWLEDGMENTS

To my talented and patient editor, Cindy De La Hoz, and very creative designer, Amanda Richmond.

To my agent and biggest cheerleader, Fran Black.

To Jason, for your love, humor, and endless support. *Je t'aime.*

To my incredible family, for your encouragement and unconditional love.

To my friends, for being as excited about this book as I am.

And, finally, to my dad, who at ninety-nine years old can still constructively critique my artwork without hurting my feelings.

INDEX

A

Academy Awards, 106, 128
Adieu Philippine, 50
Aimée, Anouk, 48
Aimini, Jean-Claude, 50
Albertazzi, Giorgio, 44
Amélie (Le fabuleux destin
d'Amélie Poulain), 8, 124
...And God Created Woman
(Et Dieu... créa la femme), 14
Andréi, Frédéric, 110
Année dernière à Marienbad, L' (Last
Year at Marienbad), 44
Artist, The, 128
Ascenseur pour l'échafaud (Elevator to
the Gallows), 16
Audran, Stéphane, 92
Aznavour, Charles, 38

Belle de jour, 80
Belmondo, Jean-Paul, 34, 74
Benedetti, Nelly, 64
Benezech, Pascal, 116
Berry, Richard, 114
Besson, Luc, 120
Bisset, Jacqueline, 106
Blain, Gérard, 24, 26
Bonheur, Le, 78
Bouquet, Michel, 92
Bourseiller, Antoine, 52
Bout de souffle, À (Breathless), 8, 34
Boyer, Marie-France, 78
Breathless (À bout de souffle), 8, 34
Bresson, Robert, 100
Brialy, Jean-Claude, 24, 26
Buñuel, Luis, 80

B

Baie des anges, La (Bay of Angels), 58
Baisers volés (Stolen Kisses), 94
Bardot, Brigitte, 9, 14, 62
Bauchau, Patrick, 90
Bay of Angels (La baie des anges), 58
Beau Serge, Le, 24
Bécourt, Alain, 20
Beineix, Jean-Jacques, 110
Bejo, Bérénice, 128

C

Calfan, Nicole, 98
Cannes Film Festival, 28
Caprioli, Vittorio, 40
Cardin, Pierre, 58
Caro, Marc, 116
Castelnuovo, Nino, 68
Céry, Yveline, 50
Chabrol, Claude, 8, 24, 26, 92

Chakiris, George, 82
Chambre en ville, Une, 114
Chanel, Coco, 44
Choses de la vie, Les (The Things of Life), 102
Cinéma du look film movement, 110
Cléo de 5 à 7 (Cleo from 5 to 7), 52
Cleo from 5 to 7 (Cléo de 5 à 7), 52
Clouzot, Henri-Georges, 10
Clouzot, Véra, 10
Collectionneuse, La (The Collector), 90
Collector, The (La collectionneuse), 90
Contempt (Le mépris), 62
Cousins, Les, 26

D

Darrieux, Danielle, 114
Davis, Miles, 16
Davray, Dominique, 52
Day for Night (La nuit américaine), 106
Delicatessen, 116
Delon, Alain, 9, 86
Delon, Nathalie, 86
Demoiselles de Rochefort, Les (The Young Girls of Rochefort), 82
Demongeot, Catherine, 40
Demy, Jacques, 48, 58, 68, 82, 114
Deneuve, Catherine, 9, 68, 80, 82
Desailly, Jean, 64
Diaboliques, Les, 10
Diva, 8, 110
Dorléac, Françoise, 9, 64, 82
Dougnac, Marie-Laure, 116
Dreyfus, Jean-Claude, 116
Drouot, Claire, 78
Drouot, Jean-Claude, 78

Dubois, Marie, 38
Dujardin, Jean, 128
Duret, Marc, 120

E

Elevator to the Gallows (Ascenseur pour l'échafaud), 16
Étaix, Pierre, 98
Et Dieu… créa la femme (…And God Created Woman), 14

F

Fabuleux destin d'Amélie Poulain, Le (Amélie), 8, 124
Femme infidèle, La (The Unfaithful Wife), 92
Femme mariée, Une, 72
Femme Nikita, La (Nikita), 8, 120
Fernandez, Wilhelmenia, 110
Film titles (1950s)
 Ascenseur pour l'échafaud (Elevator to the Gallows), 16
 Beau Serge, Le, 24
 Cousins, Les, 26
 Diaboliques, Les, 10
 Et Dieu… créa la femme (…And God Created Woman), 14
 Hiroshima mon amour, 32
 Mon oncle, 20
 Quatre cents coups, Les (The 400 Blows), 8, 28
Film titles (1960s)
 À bout de souffle (Breathless), 8, 34
 Adieu Philippine, 50

Année dernière à Marienbad, L'
 (Last Year at Marienbad), 44
Baie des anges, La (Bay of Angels),
 58
Baisers volés (Stolen Kisses), 94
Belle de jour, 80
Bonheur, Le, 78
Cléo de 5 à 7 (Cleo from 5 to 7), 52
Collectionneuse, La (The Collector),
 90
*Demoiselles de Rochefort, Les (The
 Young Girls of Rochefort)*, 82
*Femme infidèle, La (The Unfaithful
 Wife)*, 92
Femme mariée, Une, 72
Grand amour, Le, 98
Hasard Balthazar, Au, 100
Jules et Jim (Jules and Jim), 8, 54
Lola, 48
Mépris, Le (Contempt), 62
*Parapluies de Cherbourg, Les (The
 Umbrellas of Cherbourg)*, 8, 68
Peau douce, La (The Soft Skin), 64
Pierrot le fou, 74
Samouraï, Le, 86
*Tirez sur le pianiste (Shoot the Piano
 Player)*, 38
Vivre sa vie (My Life to Live), 56
Zazie dans le Métro, 40
Film titles (1970s)
 *Choses de la vie, Les (The Things of
 Life)*, 102
 Nuit américaine, La (Day for Night),
 106
Film titles (1980s)
 Chambre en ville, Une, 114
 Diva, 8, 110
Film titles (1990s)

Delicatessen, 116
 Nikita (La Femme Nikita), 8, 120
Film titles (2000 and beyond)
 Artist, The, 128
 *Fabuleux destin d'Amélie Poulain, Le
 (Amélie)*, 8, 124
Fontana, Patrick, 120
*400 Blows, The (Les quatre cents
 coups)*, 8, 28
Fratellini, Annie, 98
French New Wave film movement
 Adieu Philippine, 50
 award-winning films, 8
 Beau Serge, Le, 24
 Cousins, Les, 26
 Hiroshima mon amour, 32
 Jules et Jim, 54
 Lola, 48
 Quatre cents coups, Les, 28

G

Godard, Jean-Luc, 8, 34, 56, 62, 72, 74
Goodman, John, 128
Grand amour, Le, 98
Green, Walter, 100
Guers, Paul, 58

H

Harden, Jacques, 48
Hasard Balthazar, Au, 100
Hazanavicius, Michel, 128
Hiroshima mon amour, 32

J

Jade, Claude, 94
Jeunet, Jean-Pierre, 116, 124
Jules et Jim (Jules and Jim), 8, 54
Jürgens, Curd, 14

K

Karina, Anna, 56, 74
Kassovitz, Mathieu, 124
Kelly, Gene, 82

L

Labarthe, André S., 56
Lafarge, François, 100
Lafont, Bernadette, 24
Lartigau, Gérard, 102
Last Year at Marienbad (L'année dernière à Marienbad), 44
Léaud, Jean-Pierre, 28, 94, 106
Legrand, Michel, 58
Leroy, Philippe, 72
Lola, 48

M

Malle, Louis, 16, 40
Mann, Claude, 58
Marchand, Corinne, 52
Marlier, Carla, 40
Maurier, Claire, 28
Mayniel, Juliette, 26
Melville, Jean-Pierre, 86

Mépris, Le (Contempt), 62
Méril, Macha, 72
Méritz, Michèle, 24
Meurisse, Paul, 10
Michel, Marc, 48
Mon oncle, 20
Moreau, Jeanne, 16, 54, 58, 120
My Life to Live (Vivre sa vie), 56

N

Nikita (La Femme Nikita), 8, 120
Noël, Bernard, 72
Noiret, Philippe, 40
Nouvelle vague (French New Wave film movement)
 Adieu Philippine, 50
 award-winning films, 8
 Beau Serge, Le, 24
 Cousins, Les, 26
 Hiroshima mon amour, 32
 Jules et Jim, 54
 Lola, 48
 Quatre cents coups, Les, 28
Nuit américaine, La (Day for Night), 106

O

Okada, Eiji, 32

P

Palance, Jack, 62
Parapluies de Cherbourg, Les (The Umbrellas of Cherbourg), 8, 68

Parillaud, Anne, 120
Peau douce, La (The Soft Skin), 64
Périer, François, 86
Piccoli, Michel, 62, 80, 102, 114
Pierrot le fou, 74
Pinon, Dominique, 116
Pitoëff, Sacha, 44
Politoff, Haydée, 90
Pommereulle, Daniel, 90
Poujouly, Georges, 16

Q

*Quatre cents coups, Les
 (The 400 Blows)*, 8, 28
Queneau, Raymond 40

R

Rebbot, Sady, 56
Rémy, Albert, 28, 38
Resnais, Alain, 8, 32, 44
Riva, Emmanuelle, 32
Rohmer, Éric, 90
Ronet, Maurice, 16, 92
Rozier, Jacques, 50

S

Sabatini, Stefania, 50
Samouraï, Le, 86
Sanda, Dominique, 114
Sautet, Claude, 102
Schneider, Romy, 102
Seberg, Jean, 8, 34

Serre, Henri, 54
Servantie, Adrienne, 20
Seyrig, Delphine, 44, 94
*Shoot the Piano Player (Tirez sur le
 pianiste)*, 38
Signoret, Simone, 10
Soft Skin, The (La peau douce), 64
Sorel, Jean, 80
Stolen Kisses (Baisers volés), 94

T

Tati, Jacques, 20
Tautou, Audrey, 124
*Things of Life, The (Les choses de
 la vie)*, 102
Thuy An Luu, 110
*Tirez sur le pianiste (Shoot the Piano
 Player)*, 38
Trintignant, Jean-Louis, 14
Truffaut, François, 8, 28, 38, 54, 64,
 94, 106

U

*Umbrellas of Cherbourg, The
 (Les parapluies de Cherbourg)*, 8, 68
*Unfaithful Wife, The (La femme
 infidèle)*, 92

V

Vadim, Roger, 14
Varda, Agnès, 8, 52, 78
Vernon, Anne, 68

Vierny, Sacha, 44
Vivre sa vie (My Life to Live), 56

W
Werner, Oskar, 54
Wiazemsky, Anne, 100

Y
*Young Girls of Rochefort, The (Les
 demoiselles de Rochefort)*, 82

Z
Zazie dans le Métro, 40
Zola, Jean-Pierre, 20